T0203189

I Must Have a Great Inner Life

I Must Have a Great Inner Life

Hans Hartung in his own words

Translated by Natasha Lehrer
Edited and introduced by
Thomas Schlesser

ERIS

86–90 Paul Street 265 Riverside Drive
London EC2A 4NE New York NY 10025

This paperback edition published by Eris in 2024,
under the care of the Hartung-Bergman Foundation.

fondation
**hartung
bergman**

ISBN 9781912475117

Cover: Portrait of Hans Hartung by Anna-Eva Bergman
Copyright © Designed by Alex Stavrakas

Contents

Introduction

Despite his solid grounding in classical culture, Hans Hartung cultivated a reputation for being so little fond of books that he had none on his shelves because they attracted too much dust. He also had a reputation for not being especially amenable when invited to talk about himself. In a century that had no shortage of painters willing to philosophise at length about their practice, he refused to see himself as a theorist. All of this is to say that he might not seem the ideal subject for an anthology of apophthegms and aphorisms.

But the truth is quite otherwise. From his birth in Leipzig in 1904 to his death in Antibes in 1989, Hartung lived a long and full life, with myriad opportunities for collecting anecdotes, experiences, and aesthetic reflections. He is recognised as a pioneer of the kind of abstraction known as lyrical, *tachiste*, gestural, or *informel*; he lost a limb in 1944 fighting with the Allies against the Nazis; he married Anna-Eva Bergman twice, the second time twenty-eight years after the first; and he designed an extraordinary utopian house that is now the home of the foundation that serves as the repository of his and his wife's memory.

Despite some initial reluctance, in 1976 Hartung published a memoir, entitled *Autoportrait*, that he co-wrote in French with the journalist Monique Lefebvre. Reissued in 2016 with an arsenal of notes and contextualisation, *Autoportrait* is lively, if a little all over the place: a tremendous reservoir of brilliant and often witty reflections, scattered with piquant

anecdotes about crooks creating forgeries out of two different works, collectors refusing to lend works, and caustic comments about Kandinsky and American collectors. But *Autoportrait*, though undoubtedly valuable, is not the only source through which we can hear and understand Hartung: over the course of his seventy years of making art, he gave many interviews on television and in print; like many teenagers, he kept diaries when he was young; and, of course, he exchanged letters, most notably with his wife, Anna-Eva. Miraculously, many of these documents have been preserved, and they give us a view stretching over many decades of the thoughts of a man known for his iron temperament.

Inevitably, there are differences of register: the tone of his youth, for example—in pages filled with his innermost thoughts, roiling with self-doubt and rage—bears no resemblance to the wise, poised words of his mature years. Nonetheless, a dogged preoccupation with art, science, ethics, politics, and, always, freedom, remained constant throughout his life. Hartung, who crossed paths with the Gestapo, was interned in various prisoner-of-war camps, and lived with severe disability, knew about privation. He found it, quite simply, unbearable.

Hartung spoke German and French, as well as a little Spanish, English, and Norwegian. He had a deep voice and a tendency to mumble. He wrote in a cramped hand that was analysed in the 1940s by the well-known graphologist Raymond Trillat, who described Hartung as trying to "seal off the currents

of his thought in a protective circuit". He is present-
ed here unshackled, unfiltered, liberated, offering us
the opportunity to plunge into the "great inner life"
of an immense artist.

Thomas Schlesser

A note about this book

Quotations have been drawn from a wide variety of
sources, ranging from teenage diaries to the last inter-
views Hartung gave before his death at the age of eighty-
five. Sources range from unpolished writings taken from
unpublished archival documents (including his corre-
spondence with Anna-Eva Bergman from the 1930s), to
published texts (*Autoportrait* being the most significant)
and recordings for radio and television. The quotations,
originally in either German or French, are not presented
chronologically, but rather in thematic sections.

I Must Have a Great Inner Life

On creation, its practice, and its social field

Hans Hartung's earliest signed works date from 1914, when he was just ten years old. The earliest of his abstract watercolours—the crucible of his later work as an abstract painter—date from 1922; he was still in his teens when he produced them. At the other end of the spectrum, his final working session took place on 16 November 1989. All of this to say that Hartung's long creative life gave him a great deal of time to interrogate his own practice, to observe the activities of studios, museums, galleries, and forgers, and to offer a variety of reflections on art in general. What emerges from all this? To begin with, the sense that he considers painting as a kind of summit where fundamental human qualities take shape: will, ambition, freedom, the search for harmony, vitalism. He expresses disdain for the social milieux that gravitate towards the art world: neither critics, nor the crowds at private views, nor the world of collectors and dealers is spared his sharp, caustic observations. And, perhaps most interestingly of all, Hartung displays an edifying lucidity when he talks about various technical aspects of art: the importance of accident, his own chromatic preferences (including a poignant aside on the colour pink), the role of photography, and his sense of excitement at discovering lithography. This section opens with the artist's favourite expression: "What I like is to *act on the canvas*". He often repeated this phrase in interviews and writings over the years, with slight variations; the merging of "the pleasure of living" with "the pleasure of painting" was the credo by which he lived.

What I like is to act on the canvas. The first painterly signs lead to others. Colours lead to graphics, which in turn suggest other marks, whose role, in addition to whatever they serve to express in their own right, might also be to complement, counteract, or stabilise.

<p style="text-align:center">❖❖❖</p>

For me, the pleasure of living cannot be separated from the pleasure of painting.

<p style="text-align:center">❖❖❖</p>

I am a painter, and I persist in it.

<p style="text-align:center">❖❖❖</p>

Nature—in other words, reality—is the total experience of life. It is this experience that is the source of my inspiration.

<p style="text-align:center">❖❖❖</p>

I have nothing against the canvas! I consider the canvas to be simply a trace, a witness to my wickedness, my action.

<p style="text-align:center">❖❖❖</p>

I don't believe it is possible consciously to create a disharmony and express oneself through it without first mastering harmony.

In painting, everything must be just so: lines, curves, shapes, angles, colours, all the elements that create an image which will endure, which will catch the attention, which will be the definitive expression of a phenomenon or an emotion. I like precision because it corresponds to the possibility of a lasting equilibrium. And only precision can truly satisfy the eye, the ear, and the mind.

❖❖❖

Long live art! I rejoice endlessly in creation.

❖❖❖

I'm the most purely reactive painter there is.

❖❖❖

When I decided that I wanted to become a painter, making marks was a kind of revolution, like a rejection of others.

❖❖❖

What matters to me is not to let other people or myself impose limits. To be entirely free to change and do something else, even if my new approach risks being less resonant than the previous one.

❖❖❖

I like black. It's definitely my favourite colour. A black that is absolute, cold, deep, intense. I've often used it on a light background. I like colours that allow for strong contrasts: strokes, lines, and shapes stand out boldly.

<div align="center">❖❖❖</div>

I've always preferred cool colours: blue, very pale turquoise, lemon-yellow, a brown so dark that it is almost black, or has a greenish tinge. I find that the purer a cool colour is, the easier it is to breathe. There is something resounding, vibrant, ringing about the colour yellow. Green is more restrained, more atmospheric, more aquatic.

<div align="center">❖❖❖</div>

What I don't like is green, true green, the colour of grass. I like it to be cooler, a little dark, or the opposite, very pale.

<div align="center">❖❖❖</div>

For a long time, I had little occasion to see life through rose-tinted spectacles. Pink is not a colour I like, and I almost never use it.

<div align="center">❖❖❖</div>

I use photography to remember faces, as a way of storing up life as it happens.

<div align="center">❖❖❖</div>

Everything, as far as I'm concerned, is worth photographing: a crack in a wall, clouds, anything.

❖❖❖

I deal with reality through photography.

❖❖❖

Making [sculpture] *is a lot of fun. You make a ghastly racket, hammering, banging, scraping: the devil would have the time of his life!*

❖❖❖

Over the last few years [between 1970 and 1975], *I've been fortunate to have had the opportunity to broaden my own possibilities of expression by means of a new material: lithographic stone. I've been using it periodically since the war, and it has become one of my favourite techniques. I've also begun making woodcuts. The rocks and trees of Switzerland haven't been spared—and there are some marvellous ones. Not only have I found it easier to etch on a large scale with lithographic stone than with wood but, thanks to the grain of the stone, the results have an astonishing clarity. Working in monochrome—for those who accept the constraint—allows for greater speed and almost instant results. I think it is the most noble form of this art.*

❖❖❖

Art is a manifestation of determination.

<center>❖❖❖</center>

Art is a cry of life in the world.

<center>❖❖❖</center>

However profound, a theory of harmony must only be a base, a tool, a bit like syntax and rhythm are for a poet.

<center>❖❖❖</center>

There is no such thing as a law of beauty.

<center>❖❖❖</center>

In the world of art, nothing is more difficult to digest than a solidly constructed doctrine.

<center>❖❖❖</center>

Thoughts on a grand scale must be painted on a grand scale.

<center>❖❖❖</center>

A small format doesn't suit me; it sort of makes me look like I have no neck. Don't you think that anger, rebellion, excitement, emotion look a bit ridiculous on a twenty-centimetre square?

<center>[18]</center>

[An accident] *is always accepted if it's happy. I like the failures that give life to a picture.*

<center>❖❖❖</center>

The less important things must also figure somewhere, not just the successes.

<center>❖❖❖</center>

I don't understand those painters who always draw or paint the same thing, in the same way, their entire lives. How do they not get bored, how come they don't tire of the endless repetition? Repetition that is perhaps even more frequent in figurative painting.

<center>❖❖❖</center>

We see the churches and the painted works of the Middle Ages with a different eye to that of those who lived in the Middle Ages.

<center>❖❖❖</center>

Isn't a wall, when the light plays on it at different times of day, just as beautiful as a painting?

<center>❖❖❖</center>

It's not the job of a painting to show movement in ways that are foreign to it.

New ideas call for new techniques and, therefore, new tools, but techniques and tools also engender new ideas.

<div align="center">❖❖❖</div>

In my opinion, there are certain laws in art when it comes to painting. It all has to be planned out, it all has to be sectioned, and it all has to be real—in the pleasure it gives you, in the surface area, in the rhythms, in the angles that form. Figuration should also be subject to these laws.

<div align="center">❖❖❖</div>

I think of art as a means of defeating death.

<div align="center">❖❖❖</div>

Painters, or artists—if they are truly artists—and other splenetic individuals rarely make ideal husbands, because their ideas are all out of kilter.

<div align="center">❖❖❖</div>

Art dealers are utter wolves.

<div align="center">❖❖❖</div>

Artists are almost completely powerless against crooks and forgers—even when it's their own work that's been forged, they are not always believed.

I think it is scandalous for a gallery to demand the entire output of an artist.

❖❖❖

When it comes to works of art, the swindler's imagination has no limits. Some even go as far as putting together two different pastels or drawings and then reproducing them to create a fake 'original'.

❖❖❖

The sale of art poses serious problems. Is it possible to put a price on beauty?

❖❖❖

It horrifies me to think of so many great works of art lying dormant in the basements of museums and galleries or being kept under lock and key in bank safes.

❖❖❖

I've always found it fascinating to own works of art that I love. I understand collectors, especially those who want to bequeath their collections to museums or other beneficiaries either during their lifetimes or after their deaths, because I truly believe that a work of art can never really be owned, but that it is, rather, a passing guest.

❖❖❖

I once sold a painting I liked very much. Not long afterwards I was preparing an exhibition, and I asked the buyer if he would agree to lend the work for the duration of the show. "Don't even think about it!" he exclaimed indignantly. "The painting belongs to my wife, and she is so jealous that she keeps it in a locked room, and no one else is allowed to look at it". It was, in a way, very flattering, but I find it unbearable to think of a painting, any work of art, being kept in a cage, a prison.

<div align="center">❖❖❖</div>

Sometimes it happens that an artist cannot bear to part with a painting or a drawing, as if it carries a potential spark for some future development.

<div align="center">❖❖❖</div>

For a painter, every drawing or painting is a part of him that demands to be seen, not kept in a cellar like a prisoner. What is the point of it if no one can see or appreciate it?

<div align="center">❖❖❖</div>

I cannot bear those elegant women at private views who shamelessly parade up and down in front of your work in garish colours that clash with the pictures, and the men who stand around chatting, completely oblivious, with their backs to the art.

I admit it's a bit of a shock to walk into an elegant gallery and find oneself face to face with a dustbin... There are so many ways to work, you can even work with a hat... But I don't want to mock an approach that for some is deeply felt.

<center>❖❖❖</center>

It is doubly delightful when you sell a painting and you know it is going to be in really good hands.

<center>❖❖❖</center>

Criticism I don't mind, though I prefer biographies, but when it comes to someone offering a history of this century—especially one that has global ambitions—we will probably have to wait until 2050!

<center>❖❖❖</center>

The painter suggests the movements of the tree, imagines the forces it is fighting—wind or storm— so that it can grow, circumvent some obstacle, seek the light, spread its roots.

<center>❖❖❖</center>

For a painter, fecundity in terms of quantity seems to me to be as important as quality. It's the same with music. If you were to put on a concert or festival devoted to the works of Albinoni, you would have to play the few works he composed on a loop. Try to put on an exhibition of an artist with only a handful of pictures. It's impossible! If you want to have any influence, any connection with other men, wherever on God's earth they may be—for connection is the whole point of our art—you need to be shown all over the world. Which means it is vital to have a decent quantity of pictures available, and not always the same ones. And quantity is also a guarantee of quality. The more one paints and the longer one works, the greater one's power of expression and the more stripped back and disciplined one's work.

<div align="center">❖❖❖</div>

On abstraction, its schools, and its debates

Abstraction is of course the defining Hartungian is-
sue, underpinning Hartung's life and his ambitions
as an artist. He describes it fairly conventionally as
a "particularly healthy kind of art" that avoids "the
anecdotal and the literary". But then things become
more complex. From Rembrandt—abstraction's great
unconscious forebear—to the New York School and
Japanese calligraphy, not forgetting avant-garde pio-
neers like Kandinsky and Klee, Hartung is careful not
to essentialise abstraction. For him it is a multivalent
term at the heart of a contentious debate. Situating
himself on the side of the "gestural" and the "lyrical",
presenting himself as a painter whose beginnings
were marked by a single preoccupation—"the plea-
sure of making marks"—he never misses an oppor-
tunity to express his reservations about the various
movements he considers to be overly intellectual. He
is wary of the symbolic and the geometric, whether
in the work of Russian artists like Kandinsky, Ma-
levich, and Larionov or in that of the Dutch artist
Piet Mondrian, because of the degree of "rigidity"
he senses in it. Not without humour, he asserts that
"everything ends up like a puzzle, or a giant game of
construction". Of course, he has huge respect for, and
is inspired by, the eminent painters of the past; but
he hopes that by declaring his difference from them
he will be understood as a painter who, while being
demonstrably abstract, is more embodied and sensi-
tive, more human. There is also a hint of envy—not
antagonistic, but not particularly generous either—
towards his American peers. It is difficult to believe

[25]

that he didn't have Pollock in his sights when, with a touch of bad faith, he declared himself to be "generally sceptical of the complete automation inherent in the style of pouring paint straight from the can".

I think abstract art is a particularly healthy kind of art, one which, uniquely, works in the pictorial without getting lost in the anecdotal and the literary.

❖❖❖

Unconsciously, Rembrandt was already working in the abstract, but he would certainly never have been able to create something abstract.

❖❖❖

I consider Kandinsky and Klee to have been great artists, but the spirit of Bauhaus had, to my taste, too scholastic a character: as soon as you are told that the triangle is the symbol of this or that, you become too aware of your own intentions, at the expense of the vital margin of creative freedom.

❖❖❖

Consider Mondrian. His work is an intellectual construction that says nothing at all about human experience—it is an openly abstract experiment.

Just the idea of listening to Kandinsky declaim his theories on constructivism — "a circle corresponds to eternity, an oval is the symbol of the feminine, yellow is the symbol of this, blue the symbol of that" — made me think to myself, "Everything ends up like a puzzle, or a giant game of construction".

❖❖❖

The Russian abstract painters like Malevich and Larionov were intellectualising. They were trying to work out the probable direction that painting was going in. That's completely foreign to me. The only thing that has ever mattered to me is the pleasure of making marks.

❖❖❖

I think of all the artists who have made big and little squares...squares upon squares, black on black, white on white: intellectualism, all of it. What remains of the human in all of this? What remains of the idea? I can't quite see.

❖❖❖

In abstract art the size of the painting is of enormous importance. The value of a figurative work, even when it is small, is in the details and proportions. Everyone knows the height of a human being, the majesty of a horse, and, thanks to perspective, these dimensions are maintained.

In abstract art—at least in what is called lyrical, gestural, or informel *abstract art—the gesture of painting must be of a dimension that corresponds to its essence. A line that crosses a two-metre-high canvas expresses intensity, vitality, strength. If it is only ten centimetres high, it becomes unimportant. Anger, rebellion, enthusiasm, or passion that is twenty centimetres high looks ridiculous.*

❖❖❖

I got into the habit of seeing figures and images everywhere, sometimes in a simple slice of bread... This is the paradox of the abstract painter, and perhaps the repression of his love for the visible world!

❖❖❖

Movement plays almost no role in impressionism, but it comes into play in abstract art. The speed with which a mark was made can always be sensed on the canvas.

❖❖❖

What I know about the beginnings of the abstract art movement is that it appeared like something completely distinctive and new. The connection with the world was lost.

❖❖❖

For me, [abstract art] *was purely instinctive.*

❖❖❖

[The word 'abstract'] *applies to a style of painting that is not, at least consciously, inspired by an exterior impression (unlike, say, in the work of Bazaine, Singier, and Le Moal) but that has as its source an inner impulse.*

❖❖❖

We must insist forcefully on the enormous psychic and spiritual difference that arose between geometric abstract art and another movement that only found real resonance after the war and from the point of view of a new generation. I want to talk about this art, which has been given various names, all fairly inaccurate—lyrical, non-figurative, abstract expressionism, informel, *gestural abstraction, action painting,* tachiste, *and so on. What these movements have in common is the rejection of the inhuman rules of abstract art as dictated by the constructivists, the suprematists, and the neoplasticists (though these movements did bring us such artists of absolute and marvellous purity as Mondrian and Sonia Delaunay). In contrast to that rigidity and dehumanisation, the later abstract movements reintroduced the psychology, sensibility, and emotions of human beings confronting fate, dependency, and their own questioning of the universe.*

[In abstract art] *there was a long easing off in formal terms, followed by a purifying tendency that originated with Cézanne and which was followed in France by analytic cubism. Once again, a mark became a mark, a line became a line, a surface became a surface. More than ever, these works live through themselves and for themselves, liberated from any deference to figurative art. This is what makes it possible to bring together again, without a distorting mirror, the principal elements of human existence: the universe, and our place in the universe.*

❖❖❖

If one were to formulate a critique of American [abstract impressionist] *painters, it would be that they are guilty of the sin of pride. The way they talk, it is as if they are directly descended from Jupiter. I'm sure they are being sincere. It is as if they desperately want to push away their aged mother Europe. I don't deny the importance and value of this young American school. I even slightly envy its acolytes, for they are better supported than those of us still living on the old continent. They have one undeniable thing going for them, national pride, which means their collectors are possessed by the idea that they own works that are typically American—New York, the Florence of the twentieth century.*

❖❖❖

Automatism never grabbed me, no more than would an expressionism only confident of its ability to express one emotion: a cry in the street is not art. What I sought was to combine the lyricism of the Germanic spirit with the remarkable structure of the Latin mind, which I found compulsively seductive.

❖❖❖

I am generally sceptical of the complete automation inherent in the style of pouring paint straight from the can. I think that everything an artist does must be done consciously and that he must never let his materials take over.

❖❖❖

I'm afraid I may have disappointed some Japanese people who believe that Western 'lyrical' abstract art descends directly from their classical art, or more precisely from their calligraphy. I think there was some influence, but to a rather lesser extent than they would like to believe. In fact, it was more of a fortuitous meeting of two currents arriving from different sources, and, moreover, in the context of abstract art it only lasted a few years.

❖❖❖

It is true that in the work of some European artists — surrealist and art informel *artists — there were painterly elements not unlike illiterate handwriting, and*

*these were sometimes executed in a trance that may
or may not have been brought on by drugs.*

On contemporary artists,
some beloved and some less so

Hartung spent a lot of time looking at the work of other artists, both classical and contemporary, and his tastes come across quite clearly. He was ecstatically admiring of Rembrandt, from whom he drew inspiration for his vocation when he was still very young. He was sceptical of the surrealists, and over the years he qualified and calibrated his opinions on various abstract artists, sometimes contradicting himself. Between his youth in Germany and his mature years, for example, his loathing of Kandinsky mellowed considerably. In 1943, after he fled France to avoid capture by the Nazis and was interned in the Miranda de Ebro prisoner-of-war camp in Spain, he gave lessons in art history to his fellow prisoners in the most miserable conditions. His library overflowed with catalogues, monographs, guides to museums, and books about ancient civilisations. Most importantly, Hartung was generous when he gave interviews, explaining his preferences and misgivings. Though his painting can seem furiously unconventional, radical, and avant-garde, what stands out from the interviews are his sources of inspiration, from the Dutch Golden Age to German expressionism, alongside a deep esteem for some of his contemporaries. This anthology contains only a small selection of quotations, which cannot do justice to Hartung's many passions. His archives contain a huge number of postcards that reproduce works by (for example) Manet, indicating an immense admiration for the French painter—and yet he barely ever talked about him. Nonetheless, despite such inevitable limitations, Hartung's words are to

be relished for his thoughtful reflections on the importance of glazing in old masters, for his comparison of Dufy with Mozart, and for the evidence of his great affection for Sonia Delaunay (among others), as well as the occasional deliciously wicked barb.

It is Rembrandt's religious and human side that drew me to him more than any other painter.

❖❖❖

I think that [Rembrandt's *Portrait of a Family*] *is the painting that has made the greatest impression on me in the world.*

❖❖❖

One painting I like very much is The Supper at Emmaus, *for the pilgrims' silence and sense of wonder.*

❖❖❖

It was in looking at [Portrait of a Family] *that I had the sudden revelation of what I was going to do with my life. In the folds and drapes of the mother's dress, I understood that Rembrandt was also making marks. Marks that exist in themselves, in their rhythm, their colour, their character, their expressiveness. I was so overwhelmed by this discovery that I almost fainted. I had to sit down on a bench and wait for the dizziness to pass.*

I always go back to Rembrandt and Frans Hals. Especially the pictures Frans Hals painted after Rembrandt's death. It's as if Rembrandt's death freed Hals; as if before that, in the great master's shadow, Hals didn't dare to work in depth, didn't dare truly to give himself to the work, as if he was too aware that he could never match Rembrandt's genius. But then he took up the torch and began, like Rembrandt, trying to plumb the depths of the human soul.

<div align="center">❖❖❖</div>

For centuries, from the Renaissance until the end of the nineteenth century, one of the distinctive characteristics and qualities of Western art was the use of glazing. In the work of Van Eyck, El Greco, Rembrandt, Dürer, Wouwerman, and so many others, the canvas had a sub-structure, usually black or grey but sometimes coloured, that only received its true tone, its definitive sheen, from the colour of the glazing.

<div align="center">❖❖❖</div>

I found my forefathers in Rembrandt, Goya, Van Gogh, Munch, and the German expressionists, while [Pierre Soulages] *took his inspiration almost exclusively from the Roman art he knew so well from his native Rouergue, from the trunks of trees and the megalithic forms found in that part of the world. Plenty to talk about for hours!*

Nolde is spectacular, primitive, robust.

❖❖❖

In terms of outside influences—leaving aside the ever-present Rembrandt factor—I think I would say the cursive aspect of Slevogt's drawings, and the breadth and expressivity of the marks that were to become so dominant in Corinth's last pictures.

❖❖❖

The most direct influence that led me to abstract art was, without doubt, the woodcuts of expressionist artists such as Heckel, Kirchner, Schmidt-Rottluff, Pechstein, and Nolde.

❖❖❖

My youth was lit up by a passion for Wagner.

❖❖❖

Of all the modern [composers], *it is Scriabin who has made the greatest impression on me.*

❖❖❖

I find Marcel Duchamp's Nude Descending a Staircase *completely off beam.*

Kandinsky disgusts me with his café music. A ridiculous gimmick. It's a desecration of the very idea of art.

❖❖❖

In a way, every one of Picasso's works is an eclectic repetition of the great human masterpieces: a deeper, sometimes caricatural, often exaggerated reworking of art history. But he also had a taste for the new that sometimes went hand in hand with a taste for pulling the wool over people's eyes.

❖❖❖

Picasso always gives an impression of genius. He could turn his hand to anything: painting, sculpture, ceramics, and his extraordinary graphic works. When he drew, it was always just right: he had confidence, an absolute precision of line that is truly astonishing, and an overflowing imagination. I consider him a very, very great artist.

❖❖❖

Picasso did an astounding amount of preparatory work for Guernica: *thousands of drawings and preliminary sketches. That was how he managed to harness the force, virility, tension, and simplicity that make this work an absolute masterpiece of humanity. No one in the future will look at it without being stunned and profoundly in awe. I regret that there*

aren't two, three, ten Guernicas *in his rich, prolific, abundant body of work... At times there is a kind of recklessness in both his work and his behaviour, an irresponsible side to him that is surprising and incongruous.*

<center>❖❖❖</center>

[Painters like John Ferren and Pablo Picasso] turn out to be quite simply a bit odd, and, unfortunately, consistently so: they brood, they do not take notice of anything in their surroundings, and they end up hurting the people around them.

<center>❖❖❖</center>

I have a weakness for Dufy too, though a lot of people don't like him. I like, for example, the power of his black boats, the warships he paints facing Nice. There is a Mozart side to him that I find very seductive: that lightness, very clear and sharp, and the play of colours like a kaleidoscope. And the way he draws with his own little rhythm, that special flowery quality he has.

<center>❖❖❖</center>

What appeals to me in Artaud is his crazy, exuberant, self-destructive side. The man was even more crazy than his poetry. He lived as if in the theatre, inside a psychic theatre, the theatre of cruelty.

<center>[38]</center>

Tobey is a spiritual son of the East, quite distant from me.

❖❖❖

[Jean Hélion] *makes beautiful things and is a good man.*

❖❖❖

To my mind, surrealism belongs more to the domain of poetry than that of pure painting.

❖❖❖

Surrealism was sullied from the start—in its very principles, in its essence—by its literary aspect: a kind of poetry that works through painted images. These things have nothing to do with painting itself. There are, for example, very bad surrealist painters who are only interesting because of their content. If you place words or ideas at the forefront, and the visual art comes second, I think it goes off course. Painting becomes a poor little servant that no longer has its own rules, its own vigour.

❖❖❖

To start with I was very taken by Kline and Pollock, and then by Rothko's marvellous work—I think he is a very great artist.

❖❖❖

Rothko's fate saddened me deeply.

❖❖❖

I have a particular predilection for Cornell and his boxes.

❖❖❖

I have no desire to say that this or that [American abstract artist] *is good or bad, or if I like his painting or not. It would make no sense. But in general I never felt very close to them. Apart from one or two, I didn't know them well, I didn't go to America to see them, and I had no connection to the way they lived. It's difficult to have the same feelings and reactions* [if you don't have] *the same history.*

❖❖❖

I have a particular weakness for Rothko and Calder, and I very much admire Soulages's work, which has so much energy and power. I also think very highly of Mathieu.

❖❖❖

In the past, time was slower; nowadays, mental development is faster. Titian, Rembrandt, Goya, Cézanne painted their best pictures at the end of their lives. People need time to fully mature.

Every era is associated with individuals, and individuals, like fruit, must mature. There are multiple examples in art history of artists who clearly made their best work only towards the end of their lives. Michelangelo, Titian, Rembrandt, Frans Hals, Goya, Turner—that extraordinary precursor of impressionism pushed to its limits—Monet, Bonnard, and many others.

<center>❖❖❖</center>

It's very hard for a man to talk about his wife's paintings. People will insinuate that you are biased. But I have to say I was surprised by the scale of the paintings that [Anna-Eva Bergman] *is going to be showing in Paris. Very large canvases, with very simple forms, but powerful and teeming with inner life. They are a lot bigger than mine. I have been building my own collection—not all of them, of course, but the ones I find most impressive. Since the war she has been using silver, gold, copper, and other metals to great effect. And in the last few years her themes have become increasingly exacting.*

<center>❖❖❖</center>

Sonia [Delaunay]*, Anna-Eva* [Bergman]*, and I have developed a close friendship whose strength comes not only from the great admiration that Anna-Eva and I have for her work, but also from her character. I cannot name a single contemporary painter who*

has given so much pure joy to people: the joy of simple, uniquely visual forms—squares, circles, rectangles—that, with a lively and loose rhythm, display expanses of the most cheerful colours, interrupted here and there by black or an austere green.

❖❖❖

Neither conceptual art nor body art corresponds to my idea of what art is.

On philosophy, politics, and ethics

Hartung often claimed that he was not literary, that he hardly read, and that he was wary of systems and theory—and it would certainly be a mistake to identify him as a great intellect. Nonetheless, as a young man Hartung benefited from an excellent high school and university education, and various documents in his archives testify to his interest in the authors of antiquity, in Romanticism, and in the fundamentals of philosophy. In her letters, Anna-Eva Bergman mentions among other things how much she enjoyed their discussions on serious topics, which often lasted through the night. In some of his writings, particularly from the 1920s, there is a strong sense of an ethics of action and an unsurprising but intense personal drive. Perhaps, over time, as he suffered increasingly traumatic experiences—emotional and existential crises, exile, a terrible war wound—he put aside his strong moral principles in favour of a more practical way of seeing the world, bolstered by the tragedies of history. Though he was on the whole politically conservative and wary of the left, Hartung was horrified by nationalism, prejudice, and the conquering spirit of certain cultures, particularly in the West. Having witnessed up close the destructive and self-destructive capacities of human beings, he comes across as extremely concerned by the levelling, decline, and disappearance of entire societies and civilisations. Ideologically, Hartung seems fairly indifferent to equality, proclaiming the virtues of "competition" and singling out freedom—the freedom to think and act as an individual—as a cardinal virtue.

One cannot be different to what one is. If it's repugnant, it's repugnant.

❖ ❖ ❖

Do everything that is immoderate!

❖ ❖ ❖

Human beings have a purpose. That is what gives them strength.

❖ ❖ ❖

Before expressing a definitive judgement about someone, it is vital to try and understand them fully, to step into their shoes; one must consider, at least once, what it means for someone to aspire to moral and material success, to have to persist, patiently, again and again, despite not getting a result, despite all the avenues that have already been exhausted.

❖ ❖ ❖

Consider what it means to spend years and years in such disagreeable circumstances vainly hoping for a little success, for some shelter from doubt and unsympathetic glances.

❖ ❖ ❖

Sometimes it means being able to wait, to persevere, even at the risk of one's nerves being sorely tested.

Resignation is an unpardonable sin. It is death. Because it corresponds to the desire of the gods to push us towards the void.

❖ ❖ ❖

Madness leads us to the edge of divinity; it lifts us beyond limits.

❖ ❖ ❖

The dead live!

❖ ❖ ❖

The world is mad.

❖ ❖ ❖

The world is sick, (because) I am not feeling well.

❖ ❖ ❖

Kissing is madness. Kissing is death. Death is the real, the great, the monumental.

❖ ❖ ❖

Madness is beautiful, madness is like alcohol.

❖ ❖ ❖

The true character of a human being is revealed in dreams; that is where a person is genuinely free of the influence of society.

Ambition is a source of suffering.

❖ ❖ ❖

There are obstacles, success, failure, but what really matters is the desire to communicate with the other, for that is the basis of all work...

❖ ❖ ❖

Changing course means giving up.

❖ ❖ ❖

In the past I thought that female psychology was as intelligible as male psychology. In reality I no longer understand the first thing about it.

❖ ❖ ❖

I think that candour in all circumstances is the best and only route to mutual understanding.

❖ ❖ ❖

I remain convinced that marriage without genuine mutual love cannot lead to true happiness, long-term happiness, for either partner. One will inevitably seek to cling to the other through a kind of existential fear—the fear of being alone.

Our intellectual life is no longer that of the Egyptians, the Assyrians, or the Indians. Their symbols and sacred numbers have absolutely nothing to do with our lives, our vision, or our experience of the world. Schönberg and Alban Berg no longer have anything to do with Palestine, Kafka with Homer, or Calder with the Sphinx. The essential thing for us is to exist, to tell of ourselves and our era, to talk about our preoccupations, and, if we feel that particular inner necessity, to assert ourselves in our paintings.

❖ ❖ ❖

If only there was no war... People are completely crazy!

❖ ❖ ❖

It can also be criminal to draw a veil over important matters for the sake of convention or for ostensibly ethical reasons.

❖ ❖ ❖

Never praise or curse a day before it is over. And never judge things that have not yet come to fruition or are yet to be fully understood by human beings.

❖ ❖ ❖

If a society collapses rapidly, there is no artistic culture that can survive.

❖ ❖ ❖

There are no laws without judges. God betrays himself through his acts. I cannot imagine that God, having created the world and its laws, would then have lost all interest in it.

❖ ❖ ❖

What bothers me about the word 'violence' is the hint of evil that it contains. Yes, I am protecting myself against something, though against what I am not sure, and I am also trying to express it, to understand the energy that inhabits every minute that we live, as well as everything that grows and exists. The whole world is energy and strength. And if we must *speak of this as violence, then we will also have to condemn the light, the gravitational pull of the earth.*

❖ ❖ ❖

I care deeply about democracy, by which I mean the right of everyone, as far as is possible, to be true to themselves, develop their own opinions, form their own judgements, and be able to express them openly and act accordingly. So many people simply follow other people's ideas, preconceived ideas; this is true even for dissenters and intellectuals. Is it not the case today that an intellectual, or even just someone who is supposed to be intelligent, is bound to be left-wing, to conform to a mandatory paradigm?

I think we need to accept competition. As much study as possible, as much effort as possible, and natural talent together offer the best chance of advancement, whether for the individual or the community.

❖ ❖ ❖

One must remain absolutely free to act.

❖ ❖ ❖

I have seen so many political parties in so many countries use the same arguments in pursuit of opposing ends, exploiting grand principles to support conflicting opinions... Every party claims to be in sole possession of the facts, just as every country thinks it is the most beautiful in the world. I studied history in Switzerland and Germany; I have lived in Norway, Spain, and France. I found the same self-belief everywhere. You begin to see how much people lie to themselves, consciously or unconsciously.

❖ ❖ ❖

The local history of every country becomes History with a capital H, with other people's histories only ever playing a subordinate role. Such apparently innate nationalism is presumably necessary in order for a country to exist. Nonetheless, it is narrow, foolishly vain, and a source of conflict.

[Western man] *has destroyed not only entire civilisations but also religions that he has sought to replace with his own. The result in most cases has been that people stop believing in their own religion but do not believe in ours either, and thus end up in an unhappy and dangerous state of instability.*

❖ ❖ ❖

Faced with the threat of the earth's overpopulation, human beings must acquire the wisdom to set limits for themselves. Overpopulation will one day inevitably lead to terrible conflict.

❖ ❖ ❖

I find in French the same clarity and rigour that drew me when I was young to study Latin. I always thought Greek seemed much closer to German. You can create words that do not exist, sentences so long that they have no beginning or end. Many German words have a double meaning (depending on intonation and context) and can be combined with other words. French, like Latin, is clear, defined, and distinct. It is more precise, requires a greater discipline of thought, and is unencumbered by Germanic fog.

❖ ❖ ❖

I believe that all our acts, thoughts, and desires persist in the universal consciousness.

Death is distinctly unappealing in any case, but the thing I fear most is that it will happen before I have had time to express everything I feel.

❖ ❖ ❖

I have never forgotten an Arabic proverb that one of my schoolteachers liked to quote: "Never take as a friend someone with whom you have yet to empty a bag of salt".

On nature, science, and the golden ratio

It is no surprise that Hartung was particularly struck by the "[human] inability to comprehend the infinitude of time and space". Nonetheless, his own curiosity did not falter when confronted with the limits of consciousness. As a young man he was a keen astronomer, and he later spent a long time constructing a compass. He was a self-taught architect and liked to go out with his camera to capture ephemeral phenomena: reflection and diffraction, rays of light, the plastic qualities of different materials. He went through a spiritual phase as a young man, even contemplating becoming a pastor at one point, but in general he had a rational mindset. He was practical, and something of an engineer at heart. He was motivated by a desire to observe the world around him, to try and pierce the mystery of its laws. He was never very keen on mathematics, but that didn't prevent him from integrating two pieces of work from high school (dating to 1922) rather unusually into one of his paintings, spattering equations with blots of ink. He had a keen interest in technique, and in this section we discover his reflections on the golden ratio, a geometrical system of composition whose proportions, as he says, "preserve the unity of the whole". It is worth pointing out that Hartung's paintings were frequently the subject of scientific, parascientific, and metaphysical interpretation, and critics have often described his paintings as "cosmic". This makes sense for works that often bear comparison with Stanley Kubrick's *2001: A Space Odyssey*.

I think nature only develops through struggle and competition. It is through struggle that selection and advancement take place. This is true throughout nature; why would it be different for human beings?

❖ ❖ ❖

A plant growing, the throb of blood, everything that is germination, growth, élan vital, vital force, resistance, pain, or joy can find its particular embodiment, its own sign, in a line that may be supple or flexible, bowed or proud, rigid or powerful—in a strident, joyous, or sinister coloured mark.

❖ ❖ ❖

Alas, moral development has not followed—far from it!—scientific progress, which, whether because of global overpopulation, or the development of insane weapons, or the continual call to violence, revolution, and war, risks driving humanity to unimaginable catastrophe. If, for example, one of those insane weapons were to fall into the hands of a terrorist, it could be used as a dreadful means of blackmail or for destruction on a massive scale—the destruction not only of ourselves but of all living things on the planet, who have as much of a right to life as we do.

❖ ❖ ❖

If you observe an anthill that has had an obstacle placed on top of it, the movements that develop are incredible and the speed astonishing. The ants run right and left, turn suddenly, circle, meet, move away, change direction at right angles, all without any hesitation. Their movements appear to us absurd, disorganised, the fruits of an uncontrollable panic. Molecules behave like ants. Their speed and movements appear crazed, chaotic, unruly. But in fact the mass of molecules is doing exactly what it is supposed to—what its laws, our laws, impose. All these tiny, frenzied movements create orderly movement en masse: a calm, assured strength.

❖ ❖ ❖

I wanted to translate in shapes and images the laws of matter, which can appear chaotic and arbitrary but are in fact organised by a will that ultimately harmonises them and maintains order.

❖ ❖ ❖

I needed proofs, certainties. I found them in the golden ratio, whose mysteries I was determined to penetrate and whose possibilities I set about analysing. I began studying the golden ratio with the same patience, stubbornness, and passion as I had devoted to copying old masters. I, who was never very good at the hard sciences, threw myself feverishly into the dreaded mathematics!

The spirit of the golden ratio became so familiar to me that I was able to apply it by instinct, even if I often felt that disharmony was essential. The reason I have been wedded to it for so long is that it corresponds to and satisfies my need for precision. Precision in what I do, precision in what I love. I always try to be as precise as possible. To find the precise, the perfect tone for the creation of harmony. In music there are systems of eleven, twelve, thirteen, I don't know how many different tones and scales, but all of them, even if they sound shocking to our ears, observe the greatest respect to strict rules, however different those rules may be in different parts of the world.

❖ ❖ ❖

The golden ratio is a quest for harmony, for precise balance, for a regular progression towards an equilibrium that will bring about lasting satisfaction. Divide a line into two equal halves: you get boredom. Cut off one seventh: the majority oppresses the minority. But there is a unique measurement that preserves the unity of the whole: the golden ratio. It consists of finding the same mathematical relationship between the small and the large sections as the one that exists between the large section and the whole.

❖ ❖ ❖

I do not think it is always obligatory or necessary to seek the golden ratio. But I do think it is a just rule in art. And why not think about it in the context of human justice too? The parallel is undeniable, even if it cannot be expressed numerically. To live according to the golden ratio could signify being level-headed, being fair about everything. It is like in music: some people ring true, while others live out of tune.

<p style="text-align:center">❖ ❖ ❖</p>

How and why does the idea of beauty arise, even though it can be so different for different people, and for different cultures and civilisations? The golden ratio offers a reasoned, if partial, response to the question: a precise and mathematical response. It is the proof of one element of beauty.

<p style="text-align:center">❖ ❖ ❖</p>

The internal power of a wave has always interested me more than the foam; similarly, when it comes to, say, a tree, I want to understand the things that make it grow—the minuscule atoms. The internal power of a cloud interests me far more than the sun's rays above it.

<p style="text-align:center">❖ ❖ ❖</p>

From Einstein to the scientists of today who have made the most radical discoveries, most recognise that in the end they have arrived at something unfathomable. This is an unfathomable for which there can be no image; in this sense I think that religions like those of Mohammedans and the people of Israel (among others) that proscribe images of God and of the human beings supposedly created in his image are right. For human beings, however respectful they may be, can only ever dishonour the truth.

❖ ❖ ❖

Scientists know far more than the rest of us, who have to feel our way through things in parallel, and on our own scale, in order to begin to understand the fact of the matter, the existence of some tension or other. These are things for which the image seems not yet to exist.

❖ ❖ ❖

We have no evidence that earth is the only inhabited planet. There may be others, with sentient beings who are perhaps less or perhaps more advanced than we are. If our thought, our consciousness, were to be destroyed, a fragment—however minuscule—of the energy of the universe (whose mass appears always to stay the same) would vanish, and that would impact its immutable laws and rules.

What strikes me most is the similarity in scale be-
tween large and small: the cosmos and our galaxy,
our galaxy and the earth, the earth and humankind,
humankind and the atom. And what strikes me next
is our inability to comprehend the infinitude of time
and space.

<div align="center">❖ ❖ ❖</div>

All our pride comes down to the fact that we are
able to stand on our hind limbs, which gives us the
freedom to move the other two. This, along with the
ten articulated fingers on our two hands, and—per-
haps—a slightly bigger brain, is the basis of our so-
called superiority. Our superiority is dependent on
our sense of balance and the fact that we can pick
up a rock and throw it in order to kill or in order to
defend ourselves, which in turn enables us to under-
stand gravity and calculate trajectories.

<div align="center">❖ ❖ ❖</div>

Happily, nothing proves that death is the end of a
human being's kernel of consciousness. I can imag-
ine, and hope pushes me to believe this, that human
spirituality, once it has come into the world, persists
and radiates forever.

<div align="center">❖ ❖ ❖</div>

On himself: from character traits
to personal history

In 1989, already very diminished and close to death, Hartung said during an interview in his studio for a local television channel: "I must have a great inner life". In 1937 he was given a diagnosis of neurosis by the eminent psychiatrist Sasha Nacht, and he certainly was inscrutable, tormented, conflicted, and fascinating. He was open about his personality traits—obstinacy, distrust, an independent mind—and very frank in the way he talked about himself, from his phobia of storms, his frustration at not having trained as a musician, his amputation and disability, and the atmosphere that surrounded his family and upbringing: an unhappy mother, a father making endless dark warnings of impending Nazism. The Second World War, which he spent in the ranks of the Foreign Legion (initially with the French in 1940 then with the Allies in 1943 and 1944, fighting against his native country), was obviously a watershed period in his life. It also provided a perfect illustration of his character. Hartung never lived or presented himself as a hero. Indeed, though he was infinitely braver than most Germans, he never demonstrated proactive valour. But he did possess great moral rectitude: the modest and inflexible dignity of a man who could not and would not give in. "If I had given in [to Hitler], I would have given in to everything", he said. After the war he led a glamorous, happy, often dramatic life that is difficult to sum up in a few words, but which has the merit of making those few words powerfully resound.

I had a catatonic fear of storms; I literally quaked at their force and intensity. My school exercise books were filled with pages and pages of lightning bolts. My father called them "Hans's Blitzbücher", my lightning books. I am sure my childhood lightning bolts had an influence on my artistic evolution, on the way I paint. They gave me a sense of a line's velocity, of the desire to capture a snapshot with a pen or a paintbrush. They introduced me to the urgency of spontaneity.

❖ ❖ ❖

Around the age of thirteen or fourteen I was very spiritual, obsessed with converting my classmates. I dreamed of becoming a missionary. But my father cunningly encouraged me to take an interest in astronomy. As a way of instilling doubt about the absolute veracity of religious ideas.

❖ ❖ ❖

I have always regretted having had to give up studying music. However hard I tried, I could never sight-read a piece of music, I couldn't read the notes. I was diagnosed with defective vision by an eminent professor, a renowned ophthalmologist and friend of my grandfather. He prescribed glasses to correct my astigmatism. It didn't improve things—quite the opposite. The professor increased the prescription at my next appointment. Then he decided he needed to

operate. "Both eyes", he said. "It's the only solution".
I was fifteen, and overcome by panic. Happily for me,
the eminent professor died suddenly the very same
week, before he had a chance to operate. I went to
see another specialist who asked me what idiot had
been treating me. It turned out that the treatment I
had been given by the eminent professor was the op-
posite of what was needed. Thanks to his successor,
my vision gradually returned to normal. But it was
too late to continue studying music. I was fascinated
by so many things in this world, and inevitably I had
to choose.

❖ ❖ ❖

For years I had to console my mother. She was always
in bed, weeping and moaning.

❖ ❖ ❖

I had to fulfil my mother's wish, by serving humanity
with my art.

❖ ❖ ❖

If I ever have any success, people will respect me pre-
cisely for having been tenacious and stubborn, for
having been patient, for having sacrificed everything
to a single cause.

❖ ❖ ❖

I tend to be pessimistic, unforthcoming, and sceptical. That is to say, I am not attracted per se *by things that are new or unfamiliar. But I want nothing more than to be persuaded.*

❖ ❖ ❖

I don't think I have an icy temperament.

❖ ❖ ❖

I want to remain free. In spirit, thought, and action.

❖ ❖ ❖

Even with the best will in the world, I cannot be someone different to who I am right now, because of course neurotics cannot help themselves.

❖ ❖ ❖

[My father] *foresaw the extent to which Hitler's coming to power would be a tragedy for Germany and the world. If I had had a child* [with Anna-Eva Bergman], *and if we had wanted that child to have a decent life, we would have been forced not only to compromise but perhaps, despite everything, despite Hitler, to remain in Germany. Even today it seems obvious to me that so many ordinary Germans—obviously I am not talking about fanatical Nazis—put up with or tolerated Nazism not because they were*

afraid for themselves, but because they were afraid for their families. Opposing Hitler and Nazism meant putting the lives of one's children and parents at risk. Anticipating the battles to come, I could not bear to have my hands tied.

<div align="center">❖ ❖ ❖</div>

I was shattered when I arrived in Paris in 1936. I was haunted by the bestial, tormenting world of Nazism.

<div align="center">❖ ❖ ❖</div>

I did not want to give in. I could not give in. I could, of course, have compromised and made concessions. I could have tried to make fashionable art that would have sold. I could have designed scarves. But by the same token I could also have gone back to Germany, become a Nazi, supported Hitler. Equally I could have chosen not to enlist. If I had given in, I would have given in to everything.

<div align="center">❖ ❖ ❖</div>

Once I make a promise, I keep my word under all circumstances.

<div align="center">❖ ❖ ❖</div>

Throughout my life I have been extremely sensitive to any sudden, unexpected noise, even the pop of a champagne cork. Imagine what it was like during the war! If we are going to detail the most distinctive aspects of my psyche, the impact of the claustrophobia brought about by my solitude as a child, the various periods I spent in prison and in concentration camps, and the fact I was kept handcuffed to a fellow prisoner, mustn't be overlooked; traces of all these things can be seen in the paintings I made after the war.

❖ ❖ ❖

In May 1943 I returned to serve in the Legion. Then there was D-Day, followed by the pursuit of the Germans along the Rhône Valley. It was as we were approaching Belfort, during the attack, that I lost my leg. A horrible injury; two nights without penicillin; gangrene. I have struggled ever since; losing a limb is a difficult handicap, very difficult psychologically, and worse still for a painter. I have never been able to get used to wearing a prosthesis.

❖ ❖ ❖

I am happy, proud, and grateful that I have a wife whom I have always been able to count on absolutely.

❖ ❖ ❖

I almost always work to music. Schütz, Bach, Corelli, Vivaldi, Rameau, Telemann, Handel, Purcell, Guillaume de Machaut, Marc-Antoine Charpentier, and Couperin transform the studio into an isolated musical capsule, completely cut off from the outside world. Having said that, it is very rare for the music's rhythms to influence the rhythm of my pencil or of any other tool. That is why I prefer Bach to any other composer. Although it has no direct influence on my work, the serenity of his music, its austerity, its drama, the repetitive rhythm of the counterpoints, enables me to free myself from everything that is not right there on the canvas before me. Its influence is simply mood-enhancing.

❖ ❖ ❖

I use music the way other people use alcohol or coffee or something like that.

❖ ❖ ❖

I loathe jazz. It sets my teeth on edge.

❖ ❖ ❖

I am a night owl. As it grows dark, I have this urge to improvise, to feel my way towards an instinctive way of painting. I use the daytime to rework the work I do by night. But it is the night that inspires me.

I must be honest, I'm not literary. I prefer instinctive, unmediated artistic expression like painting, sculpture, and music. Let's face it, writers have a lot of nerve. Much more than we painters. They expect us to spend hours, entire days with their work. Does a painter insist you spend fifteen hours, a whole day, looking at a picture? Try reading a book in an hour, or in five minutes.

❖ ❖ ❖

I must have a great inner life.

Afterword
The man who lived in his studio

Hans Hartung's vocabulary was made up first and
foremost of what he created in his studio with the
tools he had to hand. He deployed these tools in ways
that were both free and methodical, rather as a poet
uses words. His expression was not verbal but visual
and physical: he worked surrounded by boards, mas-
sive paintbrushes fashioned out of branches, garden
sprays, automobile paint sprays, combs, burnishers,
lithography rollers, gloves, hats, crutches... and pots
of paint, so many pots of paint, the promise of col-
ours to be splashed onto the canvas or squeezed onto
the floor, the walls, the ceiling. Studios are often
extraordinary places: repositories of myriad works
of art, and sanctuaries for beauty, ambition, anger,
murmurs. What an immense opportunity it is for me
that I get to spend so much time in Hartung's stu-
dio in Antibes, which rejoices in an excellent state of
preservation. When the Hartung-Bergman Founda-
tion opened to the public in 2022, I decided, in the
face of some opposition, to restore its human dimen-
sion. I put back the easels, positioned the rugs on the
floor, and set in pride of place Hartung's wheelchair,
in which one might almost imagine that one can see
his ghost—even more so since I decided to play in
the background a handful of recordings in which he
can be heard speaking in French. The so-so quality
of these recordings, as well as Hartung's accent and
his slightly broken French, mean that his words are
not always completely intelligible. But against this
static something becomes clear, almost like a re-
sounding declaration: Hartung's real home was his

studio. This is where he truly inhabited the world, his world. Hartung traversed wars and continents, led a romantic life worthy of a Hollywood movie, and lived in many places—from Leipzig to Oslo, from the Balearic Islands to the barracks of the Foreign Legion, in misery in Franco's camps and in luxury in Paris and Antibes. But it was only when he stretched a canvas, picked up a paintbrush or a piece of charcoal, got ready to paint inside a bubble of music by Bach or Handel, that he was truly at home in his own world. What joy it is to be able to gain access to this world through his words and his works, as though piercing the heart of a mystery.

Sources

The quotations in the French edition of this volume were taken from a variety of sources, some of which were originally in French and some of which were translated from German. The entirety of the English text has been translated from the French edition.

Autobiography

Hans Hartung, Autoportrait (Dijon: Les Presses du réel, 2016; first edition published by Grasset in 1976, based on lengthy interviews with Monique Lefebvre).

Unpublished autobiographical documents

Hans Hartung's private diaries (1922–4), held at the Hartung-Bergman Foundation.

Hans Hartung's correspondence (1936–51), held at the Hartung-Bergman Foundation; primarily letters to and from Anna-Eva Bergman, Will Grohmann, and Madeleine Rousseau.

Press

Jean Saucet, "Visite d'atelier, Hans Hartung", Arts, 17–23 April 1953.

Roger Bordier, "L'art et la manière, Hartung ou l'improvisation", Art d'aujourd'hui, March–April 1954.

Michel Conil Lacoste, "L'artiste par lui-même", Le Monde, 16 January 1969.

Maurice Rheims, "Hartung ou le dompteur de comètes", Les Nouvelles Littéraires, 17–23 December 1971.

François Pluchart, "Un geste vers l'absolu. Entretien avec Hans Hartung", arTitudes international, October–December 1974.

Alain Jouffroy, "Les idéogrammes de la fureur. Conversation de Hans Hartung avec Alain Jouffroy", Opus international, January 1975.

Bernard Noël, "La biographie, c'est important pour la connaissance de la peinture", La Quinzaine littéraire, 1–15 December 1976.

France Huser, "Monsieur Hans et docteur Hartung", Le Nouvel Observateur, 18–24 July 1981.

Audiovisual Sources

Olivier Ricard, "Une visite à Hans Hartung", Champ visuel, ORTF, Channel 2, 1969.

Pierre Braunberger and Christian Ferlet, Hans Hartung, Les films de la Pléiade, 1970.

François Le Targat, interviews with Hans Hartung, France Culture radio, 1973.

Feature for FR3 Côte d'Azur, with an interview with Henri Goetz, 1989.